Buddhas in the Palm of Your Hand:

Soothing words of Buddhist wisdom

© 2018 PIE International

English translation © Michael Jamentz and PIE International

All rights reserved.

ISBN 978-4-7562-5169-5 (outside Japan)

Foreword by Mutsuo Takahashi

Translated by Michael Jamentz

Art direction by Kazuya Takaoka

Designed by Toshimasa Goto and Miho Kanzaki

Edited by Eriko Hara

Special thanks to Luke Thompson

Printed in Japan

PIE International Inc.

2-32-4 Toshima-ku, Minami-Otsuka, Tokyo

170-0005 JAPAN

international@pie.co.jp

Buddhas
in the Palm of Your Hand

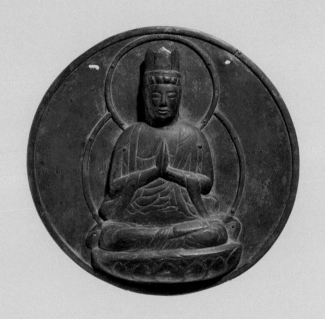

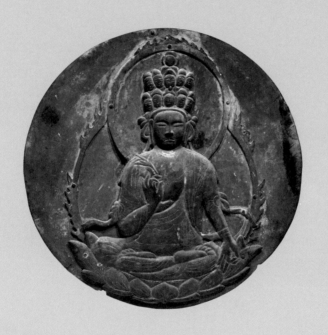

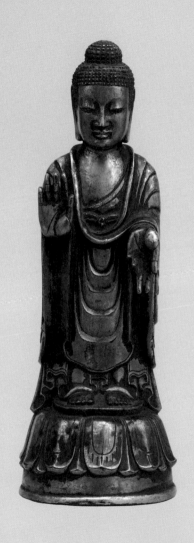

てのひらのみほとけ

Buddha からほとけへ

高橋睦郎

　ほとけという言葉はなかば外来語であり、なかば日本語である。Buddha というサンスクリット語、またはその漢訳の仏をほとと聞き取り、それだけでは気がすまずけと付けてやっと落ちついた。けはけはいのけであり、霊妙なものの謂である、という。身分を超えて広くうたわれた平安時代の今様うたに

　　　　仏は常に在せども
　　　　現ならぬぞあはれなる
　　　　人の音せぬ暁に
　　　　仄かに夢に見えたまふ

とあるとおり、現実でない霊妙な存在で、たとえば暁暗の目覚めぎわの夢の中におぼろに見える尊いもの。しかし、信と不信とのあいだを揺れ動く人間の身としてはそれだけでは捉えどころなく頼りないので、像に刻み絵に描く。じつはけとは形あるもの、だからほとけとは仏像のこととする説もある。

　Buddha＝仏＝ほとがほとけとして定着するまでには激しい闘いの期間があった。六世紀半ば、欽明期に仏教が公伝されて半世紀後、用明帝が病のため仏教に帰依することを諮ったところ、朝廷の両実力者の大連物部守屋は反対、大臣蘇我馬子は賛成、両者兵を集めて大乱に到ったこと、『日本書紀』の伝えるとおり。勝った蘇我氏ものちには同じく賛成派の山背大兄一族を殲し、やがて中大兄らに滅ぼされている。ほかにも史書に記されない

血なまぐさい相剋は少なからずあったはずだ。

　その中で祈りの対象として多くの仏像が輸入され製作された。中には念持仏（ねんじぶつ）と呼ばれる、文字どおりてのひらに乗る大きさのつつましい仏たちも少なくない。てのひらは手の平、他を愛（いと）しみもすれば傷つけもする手を平ら（たい）に開いて仏を乗せる。てのひらに乗った仏たちは等しく言うかのようだ。我を乗せたてのひらから始まって汝自身ほとけになりなさい、と。今様うたには次のようにある。

　　　仏（ほとけ）も昔は人なりき
　　　我等も終（つい）には仏なり
　　　三身仏性（さんじんぶっしょうぐ）具せる身と

　　　知らざりけるこそあはれなれ

From *Buddha* to *Hotoke*

Mutsuo Takahashi

Hotoke, the Japanese word for Buddha, is half a foreign loan word and half native Japanese. The Chinese *fo*, from the Sanskrit *buddha*, was heard in ancient Japan as *hoto*. But *hoto* was insufficient and people ended up adding the suffix *ke* to the word. This same *ke* appears in the Japanese word *kehai*, meaning portent or sign. *Ke* itself refers to spirit that is somehow marvelous and mysterious. An *imayō*, a type of song that was popular among all social classes during the Heian period (794-1185), goes as follows:

> Though the Buddha is always with us,
> It is truly sad
> He does not appear before our eyes.
> But in the silent voiceless dawn,
> He comes phantom-like in our waking dreams.
> The existence of this unseen marvelous spirit is like some

wondrous being glimpsed vaguely in the dawn twilight when we are half awake. However, because we cannot rely on such ungraspable human forms that occupy the shaky ground between faith and disbelief, we have carved them in wood and we have painted them. In fact, one theory tells us that these marvelous spirits, the *ke*, do in fact have form, and thus the *hotoke* have become Buddhist icons.

A long period of bitter strife continued before the evolution from Buddha to *fo*, to *hoto* and finally *hotoke* was finally settled. A half-century after Buddhism had been officially introduced into Japan in the mid sixth century during the reign of Emperor Kinmei (509?-571?), the ailing Emperor Yōmei (?-587?) declared his faith in Buddhism. Two powerful factions at the imperial court were split, with the Ōmuraji Monobe no Moriya (?-587) opposing the new faith and Ōomi Soga no Umako (?-626) supporting it. According to the *Chronicles of Japan* (*Nihon shoki*), both sides gathered forces and major fighting ensued. Umako's victorious Soga clan next turned on their fellow supporters of Buddhism, Yamashiro no Ōe (?-643) and his family, who were destroyed. The Soga themselves were then eliminated by Naka no Ōe (626-672). It is quite likely that many other bloody

rivalries, which have simply not found their way into the history books, also took place.

During this period of struggle, many Buddhist icons that served as objects of worship for the faithful were either produced in Japan or imported from abroad. Among these icons were many known as *nenji butsu*, a term indicating a portable Buddhist icon to which one might pray. These Buddhas were of modest size and could fit on the palm of one's hand. The palm, an open hand, can demonstrate love for another, inflict pain, or hold a Buddha. The Buddhas nestled on the palms of our hands all seem to be saying the same thing: "You on whose hands we rest, you yourselves are destined to become Buddhas." An ancient *imayō* song put it this way:

> Once long ago,
> The Buddha was a human being.
> In the end,
> We too shall all become Buddhas.
> How sad is ignorance of our bodies'
> Triple-bodied Buddha nature.

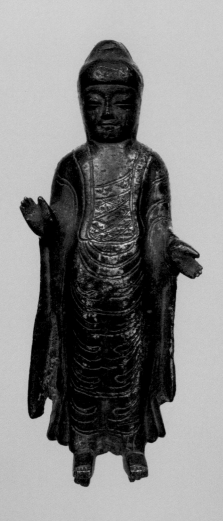

春花秋菊咲向我
暁月朝風洗情塵

春は桜、
秋は菊が咲いて私にほほ笑み、
暁の月、
朝（あした）の風が心の塵を洗う。
（「山中有何楽」『性霊集』空海）

Spring [cherry] blossoms and autumn
chrysanthemums in bloom smile upon me.
The dawn moon and morning wind cleanse
all impurities from my heart
(*Shōryō-shū* by Kūkai)

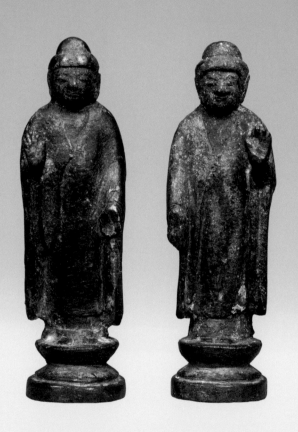

心為法本
心尊心使

さまざまの事は、
心をもととし、
その心尊く、
心によって使わる。
（『法句経』雙要品）

All phenomena are
Generated by our minds,
Guided by our minds and
Governed by our minds.
(*Dhammapada*)

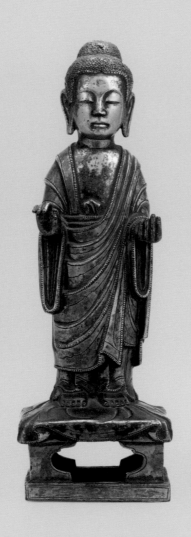

万木の開花は、
法身の色相なり。
千鳥の囀枝は、
真佛の説法なり。

あらゆる草木に花開くことは、
仏の姿のあらわれである。
あらゆる鳥のさえずりは、
まことの仏の説く教えである。
（『諷誦啓朦集』観空）

The flowers that bloom on every tree are
manifestations of the Buddha's body, and
the chirping of all birds is the sound of the true teaching
intoned by the Buddha.
(*Fujukeimōshū* by Kankū)

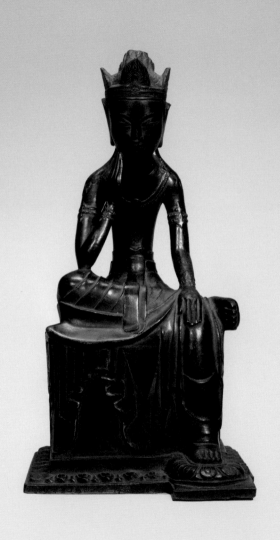

色不異空　空不異色

色即是空　空即是色

目にみえる姿や形は空であることと違わない。
空であることは形として在ることと違わない。
したがって、
形あるものはすなわち実体なきものであり、
実体がないことがすなわち形あるものである。

〔『般若波羅蜜多心経』〕

Form differs not from emptiness, nor emptiness from form.

Form itself is empty, and emptiness itself form.

(*Perfection of Wisdom Sutra*)

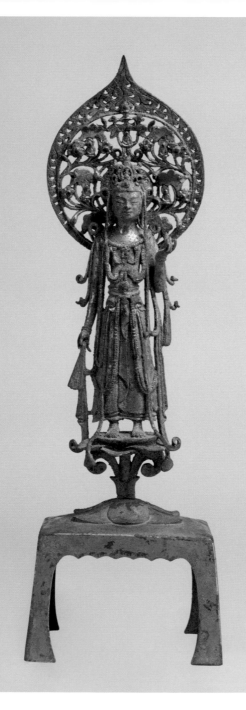

一切有為法　如夢幻泡影
如露亦如電　応作如是観

あらゆる事象は、
夢や幻や泡や影のようであり、
露や雷光のようである。
この世をそのように、
観てみるがよい。
（『金剛般若波羅蜜経』）

All that is, it is but a [passing] manifestation,
Like a dream or a phantom,
Like a bubble or a shadow,
Like the dew or a flash of lightning.
Thus one should view our fleeting world.
(*Diamond Sutra*)

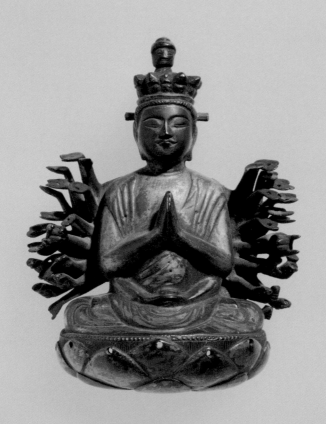

生死非常空　能観見為慧

欲離一切苦　但當勤行道

生死にまつわるすべては非常であり空である。

これを智慧によってよく知ること。

すべての苦しみから離れたいなら

ただ勤めて道を行ずること。

〔『法句経』道行品〕

"All form lacks reality."
And when this wisdom is recognized,
To rid ourselves of all suffering,
We shall strive to practice the [Buddhist] way.
(*Dhammapada*)

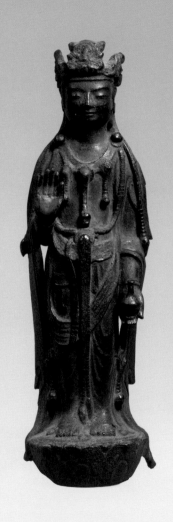

佛心者慈与悲

大慈則与楽

大悲則抜苦

仏の心は慈しみと悲れみ。
大いなる慈しみは人に楽を与え、
大いなる悲れみは人から苦しみを抜きとり、
人を救う。

（「天長皇帝於大極殿屈百僧雩願文」『性霊集』空海）

The Buddha's heart overflows with mercy and compassion.
His great mercy brings us ease and
His great compassion eradicates our suffering.
(*Shōryō-shū* by Kūkai)

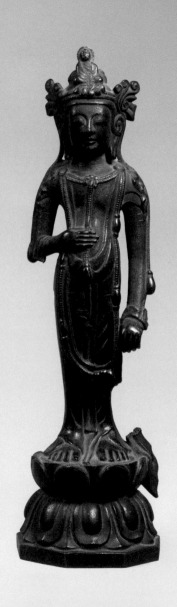

心暗即所遭悉禍
眼明則触途皆宝

心が暗くおおわれているときは、
すべてのものが禍にうつる。
眼が明るいときは、
すべてのものが宝である。

（「招提寺達嚫文」『性霊集』空海）

When our minds are cloaked in darkness,
all tends toward calamity.
When our eyes are opened brightly,
all turns instead into treasure.
(*Shōryō-shū* by Kūkai)

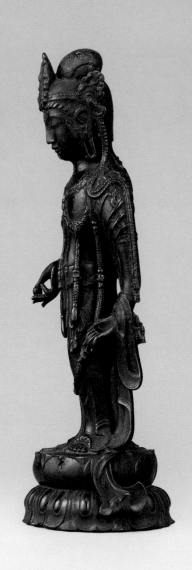

不務観彼作与不作
常自省身知正不正

他者の作したこと、
作すべきを作さなかったことを見るのでなく、
常に自らを省みて正と不正を知ること。

（『法句経』華香品）

Look not back on others' errors, their failings or achievements.
Examine yourself instead and know well the right
and wrong you've done.
(*Dhammapada*)

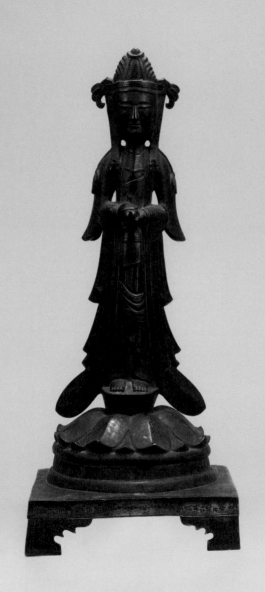

径路未知
臨岐幾泣

道がわからず、
岐路に立たされて幾たびか泣く。
（「奉為四恩造二部大曼荼羅願文」『性霊集』空海）

Ignorant of the way,
so many times I've stood at the crossroads and wept.
(*Shōryō-shū by Kūkai*)

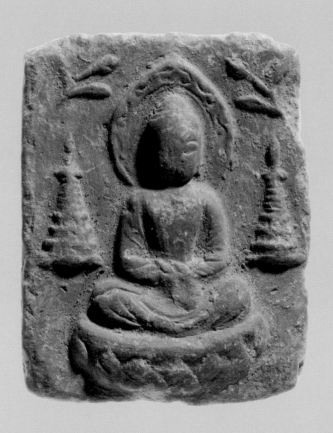

はらはらと
落つる涙ぞ
あはれなる
たまらずものの
悲しかるべし

（『山家心中集』西行）

Trickling tears mark the deepest grief. Unbearable,
the sorrow must surely be.
(*Sankashinchūshū* by Saigyō)

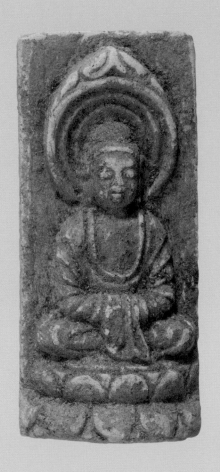

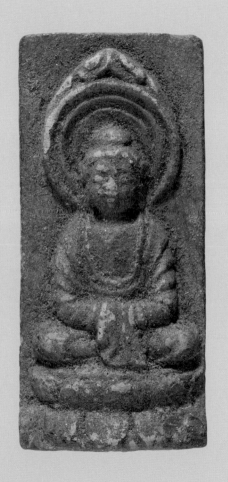

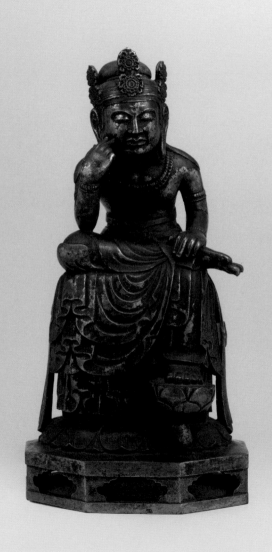

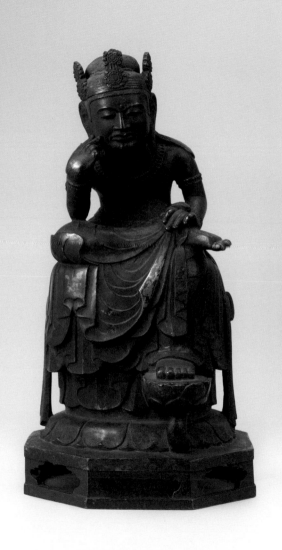

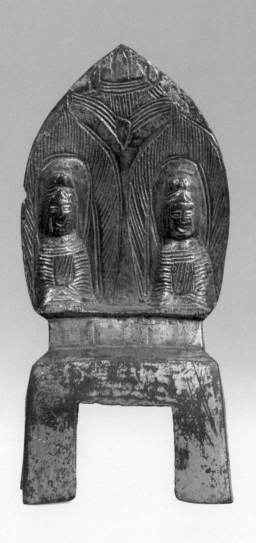

もろともに
眺め眺めて
秋の月
ひとりにならむ
ことぞ悲しき

秋の月をいつも一緒に眺めてきた。
これからは独りになってしまうことが悲しい。

（『山家心中集』西行）

The autumn moon
[We] viewed together
Time and time again.
How sorrowful,
To now view it all alone.
(*Sankashinjūshū* by Saigyō)

命をも
罪をも露に
たとへけり
消えばともにや
消えんとすらん

（『金葉和歌集』覚樹）

It is to the dew that
Both our lives and sins
Have been likened.
Were they to together vanish
That they'd surely do.
(Poem by Kakuju, *Kin'yō Wakashū*)

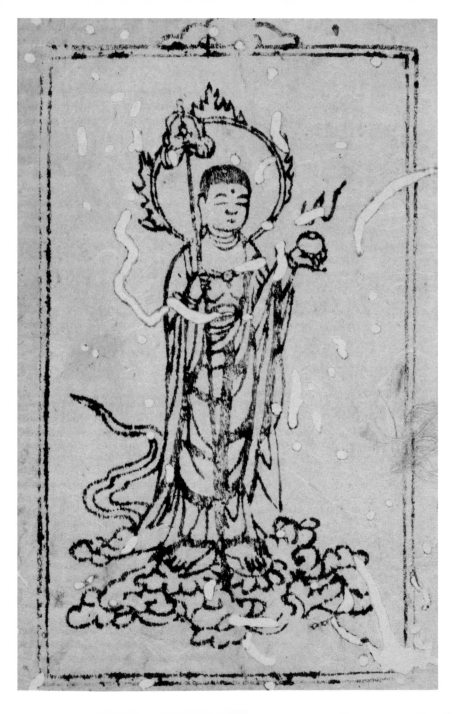

ゆく河の流れは絶えずして、
しかももとの水にあらず。
淀みに浮かぶうたかたは、
かつ消えかつ結びて、
久しくとどまりたるためしなし。
世の中にある人とすみかと、
またかくのごとし。

（『方丈記』鴨長明）

Ceaselessly the flowing river runs.
Its waters never stay the same.
Eddying in its pools, bubbles burst and then form again,
Not a thing is there that lasts.
And so it is with our world
Its people and their dwellings, too.
(*An Account of My Hut* by Kamono Chōmei)

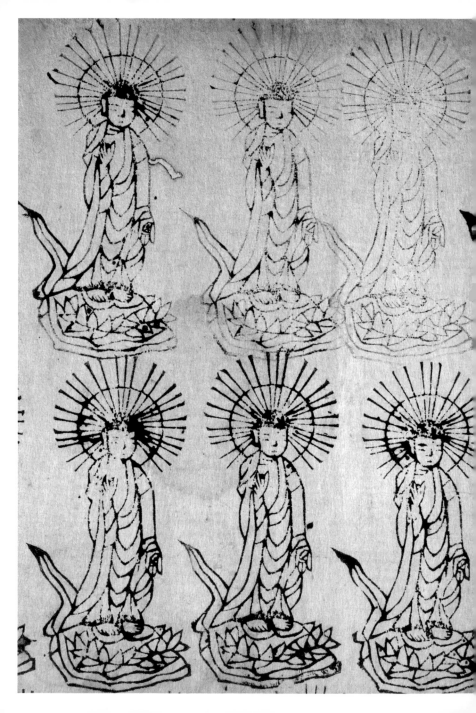

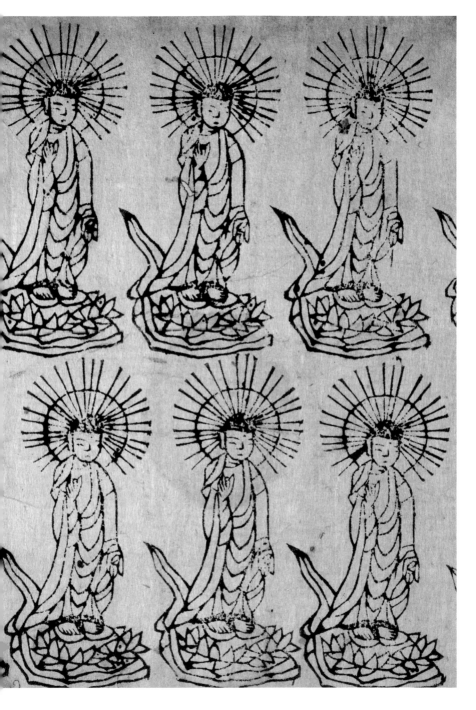

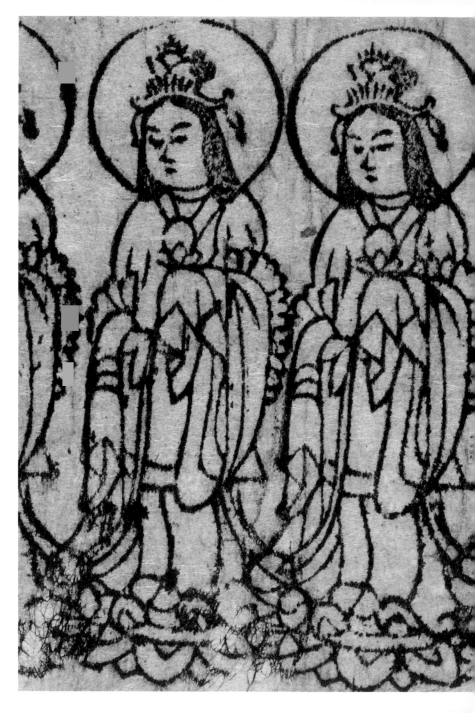

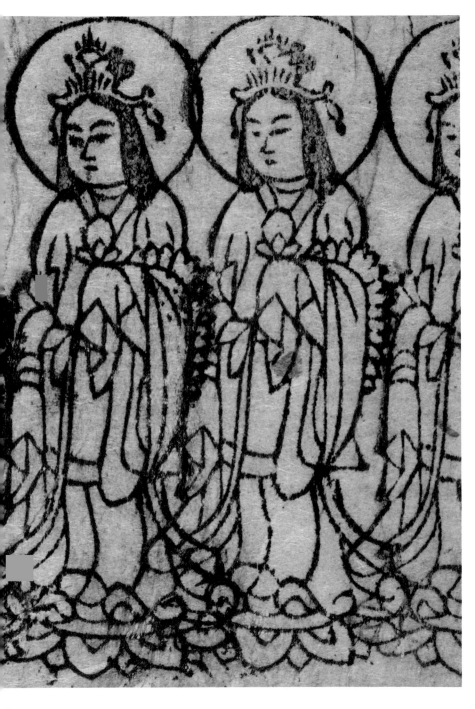

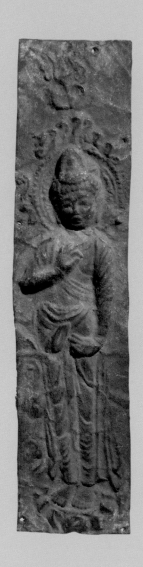

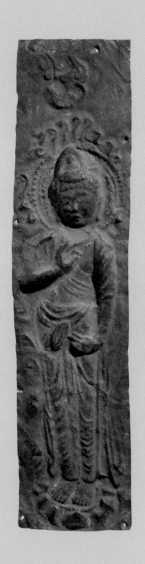

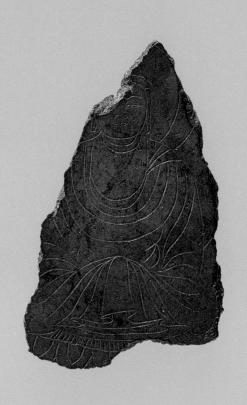

先帝翫弄之珎　内司供擬之物
追感疇昔　觸目崩摧　謹以奉献

先の天皇の大切にされた宝物は
内司の供する物である。
在りし日が思い出され、
目に触れると心砕かれる。
ゆえに謹んで献じ奉る。
『国家珍宝帳』

These belongings once cherished by [my husband] the late emperor
are now rare treasures to be presented by palace officials.
They bring visions of days long past, tearing my heart asunder—
thus I make this offering [to the Great Buddha].
(*Kokka-chinpōchō* or List of the Nation's Rare Treasures)

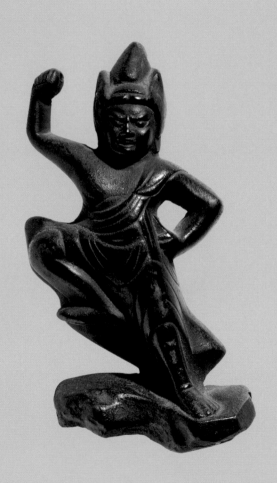

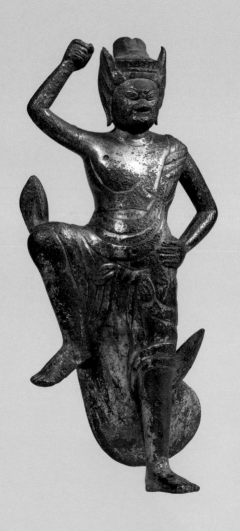

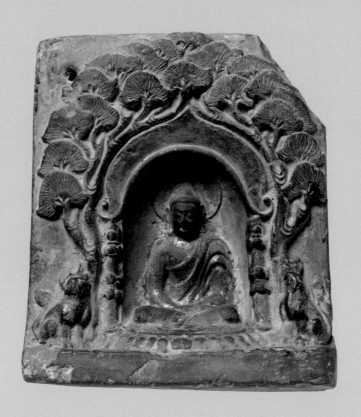

死生之分之物大帰矣
起也名生帰之称死

虚無から起ることを生と名づけ、
虚無に帰ることを死と称す。
死と生とを分けるもの・物事の帰する根本である。
〔「為酒人内公主遺言」〕『性霊集』空海）

That which arises [from the void] we call life,
that which returns [to the void] we call death.
Though life and death are distinct, each
follows the path of the Great Return, traveled
by all things.
(*Shōryō-shū* by Kūkai)

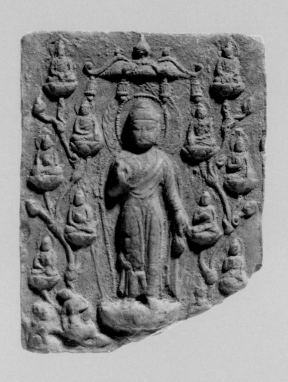

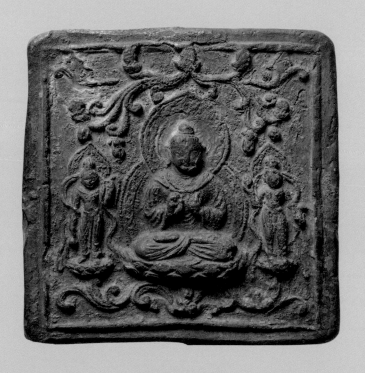

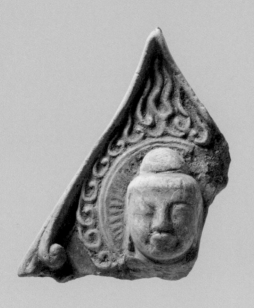

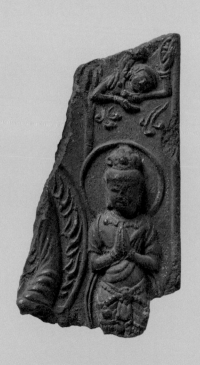

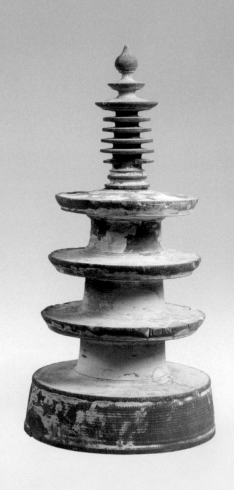

哀哉哀哉復哀哉

悲哉悲哉重悲哉

哀れなるかな、哀れなるかな、
また哀れなるかな。
悲しいかな、悲しいかな、
重ねて悲しいかな。
（「為亡弟子智泉達嚫文」『性霊集』空海）

Sad, so sad, so very sad,
It is
So full of grief and sorrow,
So sorrowful, so grievously sorrowful!
(*Shōryō-shū* by Kūkai)

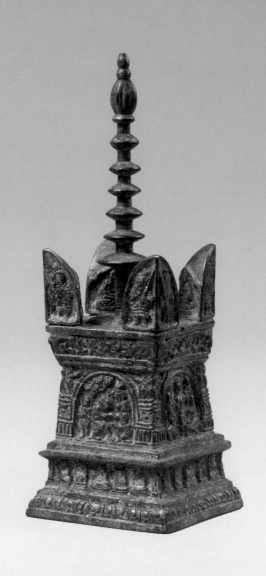

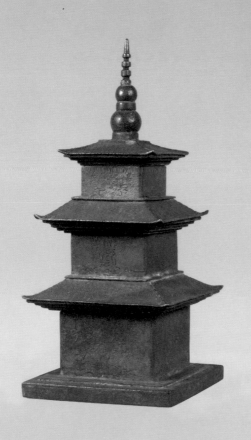

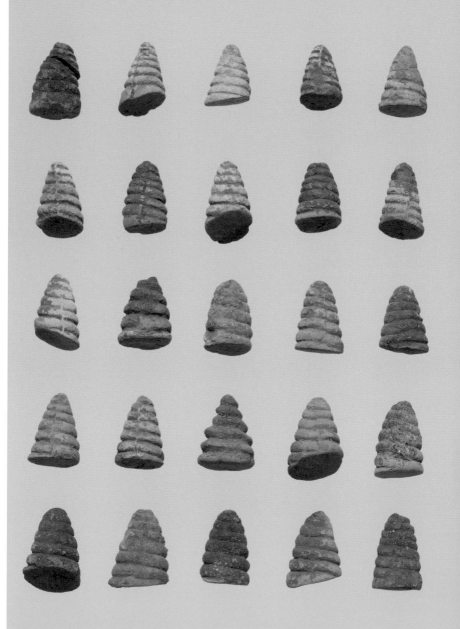

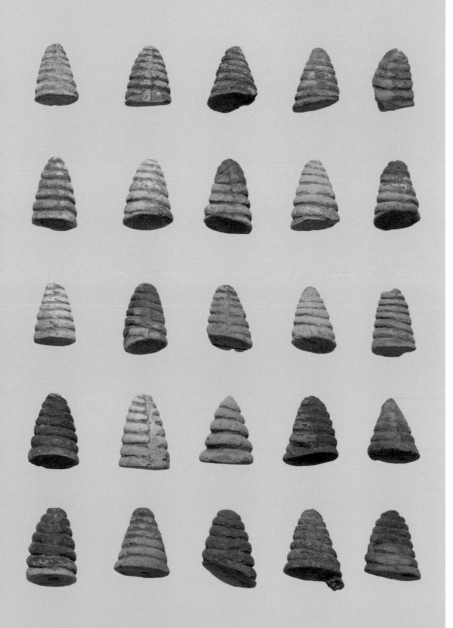

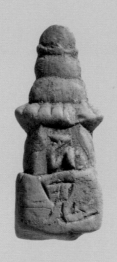

嗚呼逝歳白雪厳寒

嗚呼、
あなたの父が逝ったこの歳末
白雪、
厳寒なこと

（「藤原園人遺族宛書翰」『高野雑筆集』空海）

Alas, at the close of the year
when he [your father] passed away,
The white snow was oh so bitter cold.
(*Kōyazappitsu-shū* by Kūkai)

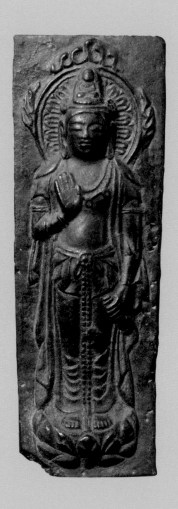

春花風に散す。

斜日の悲しみ、秋菊霜を傷む。

残月の恨み、物皆限り有り。

何れか遁る可けんや。

春の桜は風に散る。
夕陽はもの悲しく、秋の菊は霜で傷む。
有明の月は儚く、すべてのものには限りがある。
誰がのがれられようか。

（『諷誦啓朦集』観空）

In spring, the [cherry] blossoms are scattered in the wind,
And the setting of the evening sun brings sorrow.
In autumn, the chrysanthemums are scarred by the frost,
And the fleeting morning moon invites regret.
All things come to an end. Who can escape this fate?
(*Fujukeimō-shū* by Kankū)

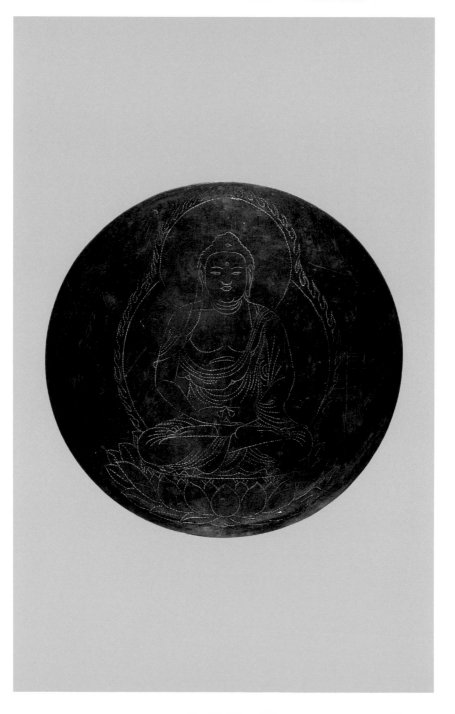

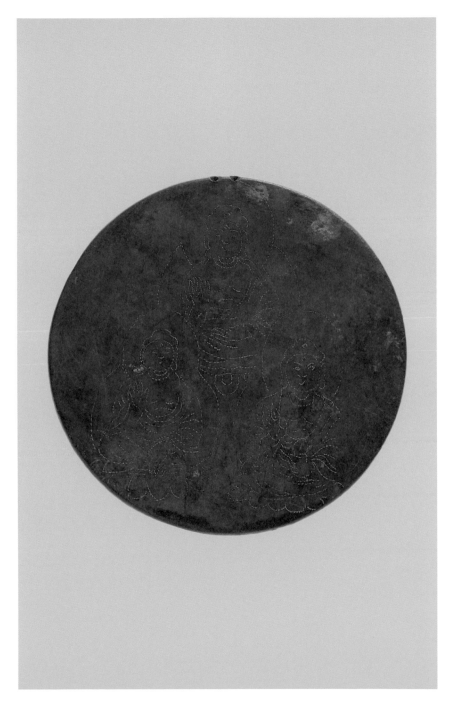

身与花落
心将香飞

身体は花の散るように果てる。
心は香のように天空を飛ぶ。
（「藤左近将監為先妣設三七斎願文」『性霊集』空海）

Though our bodies like the flowers fall,
Our hearts with the fragrance fly.
(*Shōryō-shū* by Kūkai)

南无无畏叉佛　南无胜慈佛　南无調巖佛　南无人乘力上佛　南无敬戒佛　南无師尖奮迅遊佛　南无名稱悅佛　南无除過佛

南无持意佛　南无遊光歩佛　南无一桐佛　南无師子遊歩佛　南无世悅炎佛　南无无濁意佛　南无决勘意佛　南无无王佛

南无德幢佛

南无衆生中尊佛

南无普德佛

南无天所教德幢佛

南无淨嵗佛

南无懷幢佛

南无无畏力佛

南无勝畏佛

南无法華佛

南无月幢佛

南无善意嵗佛

南无馨音佛

我等羅後信佛隨宜所說佛所出言無不皆實

亦鄰所知者皆悉通達於諸新發意菩薩於

佛滅後春聞是語或不信受而起毀法罪業

衛滅惟於世尊寸願為解說除我等疑及未來

諸善男子一同　　亦不生疑小荷佛初

表紙　誕生釈迦仏立像
1躯　白鳳時代　7c. 銅造　像高9.1
奈良国立博物館所蔵

Cover. Standing Shaka (Śākyamuni) at Birth
One statue. Hakuhō period. Bronze. H: 9.1
Nara National Museum

1. 懸仏（菩薩像）
1面　鎌倉時代　13c. 銅製　鍍金　鍛造　径22.0
裏面墨書「二　子寸□□□□」
奈良国立博物館所蔵

4. Bodhisattva in a Votive Plaque
One piece. Kamakura period. Gilt bronze in relief.
Diameter: 22.0 Ink inscription on the back
"No.2 *Ne* size [illegible]".
Nara National Museum

2. 懸仏（十一面観音像）
1面　平安時代　12c. 銅製　板金　鍛造（像）
円形　径23.6　奈良国立博物館所蔵

3. Votive Plaque of Jūichimen-kannon (Eleven-headed
Avalokiteśvara)
One piece. Heian period. Bronze in relief. Diameter: 23.6
Nara National Museum

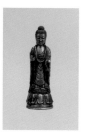

3. 重要文化財　如来立像
1躯　飛鳥時代　7c. 銅製　鋳造　鍍金　像高27.5
東京国立博物館所蔵

1. I. Standing Nyorai (Tathagata)
One statue. Asuka period. Gilt bronze, casted. H: 27.5
Tokyo National Museum Image: TNM Image Archives

4. 阿弥陀如来像（摺仏）
1幅（部分）平安時代　12c.
京都・浄瑠璃寺九品阿弥陀如来像納入品
縦43.4　横30.6　奈良国立博物館所蔵

2. Amida Buddha (Amithābha) Wood-block Prints
One sheet pasted on a hanging scroll. Heian period.
Originally enclosed inside the Amida Buddha statue of
Jōruriji-temple, Kyoto pref. H: 43.4, W: 30.6.
Nara National Museum

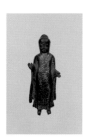

5. 如来立像
1軀 統一新羅時代 銅造 鋳造 鍍金 像高 16.0
台座・光背欠失 奈良国立博物館所蔵

5. Standing Nyorai (Tathagata)
One statue. Unified Silla period. Gilt bronze, casted.
H: 16.0 Missing a mandorla and a pedestal.

Nara National Museum

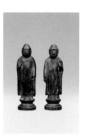

6. 重要文化財 如来立像 (伝福岡県出土経筒附)
2軀 平安時代 永久4年 銅製 鋳造 像高 11.2
奈良国立博物館所蔵

6. I. Standing Nyorai (Tathagata)
(said to have been excavated within a sutra case in Fukuoka pref.)
Two statues. Heian period. Eikyū 4 (1116).
Bronze, casted. H: 11.2
Nara National Museum

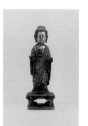

7. 重要文化財 如来立像
1軀 飛鳥時代 7c. 銅製 鋳造 鍍金 像高 29.7
東京国立博物館所蔵

7. I. Standing Nyorai (Tathagata)
One statue. Asuka period. Gilt bronze, casted. H: 29.7
Tokyo National Museum Image: TNM Image Archives

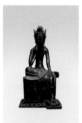

8. 重要文化財 如来半跏像
1軀 飛鳥時代 推古14年または天智5年 7c.
銅製 鋳造 鍍金 像高 38.8
東京国立博物館所蔵

8. I. Nyorai (Tathagata) in Meditating Posture
One statue. Asuka period. Suiko 14 (606) or Tenchi 5
(666). Gilt bronze, casted. H: 38.9
Tokyo National Museum Image: TNM Image Archives

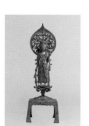

9. 重要文化財 勢至菩薩立像 (部分)
1軀 隋時代 6c. 銅製 鍍金 像高 17.1
台座は後補 東京国立博物館所蔵

9. I. Standing Seishi Boosatsu (Mahāsthāmaprāpta)
One statue. Sui dynasty. 6c. Gilt bronze. H: 17.1
The pedestal is of a later work.
Tokyo National Museum Image: TNM Image Archives

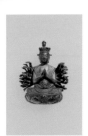

10. 懸仏残欠（千手観音像）
1個 鎌倉時代 14c. 銅製 鍍金 鋳造
総高11.8 最大幅8.8 厚5.0 鏡板欠失
奈良国立博物館所蔵

10. Senju-kannnon (Thousand-armed Avalokiteśvara), Part of Votive Plaque
One piece. Kamakura period. Gilt bronze, casted.
W: 8.8 Depth: 5.0 Missing the mirror of its background.
Nara National Museum

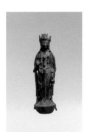

11. 観音菩薩立像
1軀 白鳳時代 7c. 銅造 蝋型鋳造
総高29.0 像高25.8 奈良国立博物館所蔵

11. Standing Kannon(Avalokiteśvara)
One statue Hakuhō period. Bronze, wax mold.
Total height: 29.0 Height of the statue: 25.8
Nara National Museum

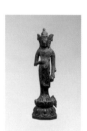

12. 観音菩薩立像
1軀 白鳳時代 7c. 銅造 鋳造 像高31.1
奈良国立博物館所蔵

12. Standing Kannon (Avalokiteśvara)
One statue. Hakuho period. Bronze, casted. H: 31.1
Nara National Museum

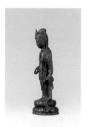

13. 観音菩薩立像 （左側面）
1軀 奈良時代 8c. 銅造 鋳造
総高39.0 像高32.7 香川・伊舎那院伝来
奈良国立博物館所蔵

13. Left Profile of Standing Kannon (Avalokiteśvara)
One statue. Nara period. Bronze, casted.
Total height: 39.0 Height of the statue: 32.7
Previously owned by Ishana-in temple, Kagawa pref.
Nara National Museum

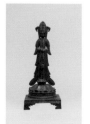

14. 重要文化財 観音菩薩立像
1軀 飛鳥製 7c. 銅製 鋳造 鍍金 像高22.4
台座台脚部銘「辛亥年七月十日記笠評君名左（また
は大）古臣辛丑日崩去辰時故児在布奈／太利古臣又
伯在□古臣二人乞願」 東京国立博物館所蔵

14. I. Standing Kannon (Avalokiteśvara)
One statue. Asuka period. Gilt bronze, casted. H: 22.4 Inscription on the pedestal indicates this was made by the wishes of the son of the late father and his uncle. Tokyo National Museum Image: TNM Image Archives

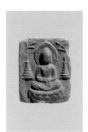

15. 塼仏（如来像）
2枚のうち　唐時代　8〜9c.
塼製　型押　縦4.7　横3.6　厚1.5（最大値）
奈良国立博物館所蔵

15. Votive Tile of Nyorai Buddha
One of two objects. Tang period. Clay placed in a mold.
H: 4.7 W: 3.6 D: 1.5 (maximum)
Nara National Museum

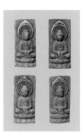

16. 塼仏（如来像）三重県夏見廃寺出土
4個のうち　白鳳時代　7c.　塼製　土製　型押　焼成
素焼　縦6.5　横2.9　奈良国立博物館所蔵

16. Votive Tile of Nyorai Buddha, Excavated from the
Abandoned Natsumi haiji-temple Site, Mie pref.
One of four objects. Hakuhō period. Clay and earth soil
placed in a mold and fired. H: 6.5 W: 2.9
Nara National Museum

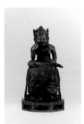

17. 重要文化財　如来半跏像
1軀　飛鳥時代　7c.　銅製　鋳造　鍍金　像高33.7
東京国立博物館所蔵

17. I. Nyorai (Tathagata) in Meditating Posture
One statue. Asuka period. Gilt bronze, casted. H: 33.7
Tokyo National Museum Image: TNM Image Archives

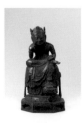

18. 重要文化財　如来半跏像
1軀　飛鳥時代　7c.　銅製　鋳造　鍍金　像高33.7
東京国立博物館所蔵

18. I. Nyorai (Tathagata) in Meditating Posture
One statue. Asuka period. Gilt bronze, casted. H: 33.7
Tokyo National Museum Image: TNM Image Archives

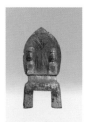

19. 二仏並坐像
1基　六朝（南北朝）時代　6c.
銅造　鋳造（一鋳）鍍金　総高12.3
奈良国立博物館所蔵

19. Two Buddhas Sitting
One object . Six dynasties period (Northern and Southern
dynasties). Gilt bronze, casted. Total height: 12.3
Nara National Museum

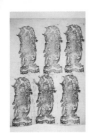

20. 毘沙門天像（印仏）
1 紙　平安時代　12c.
旧中川成身院毘沙門天像納入品　縦 39.0　長 28.4
奈良国立博物館所蔵
20. Stamps of Vaisravana
One sheet. Heian period. Originally enclosed inside the
Vaisravana statue of Nakagawa Jōjin-in temple.
H: 39.0　W: 28.4
Nara National Museum

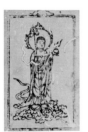

21. 地蔵菩薩像（印仏）
1 紙　室町時代　15c.　大蔵寺地蔵菩薩坐像納入品
紙本 印写 折本貼付　縦 10.5　横 6.8
奈良国立博物館所蔵
21. Stamp of Jizō Bosatsu (Kṣitigarbha)
One sheet. Muromachi period. Originally enclosed inside
the Jizō Bodhisattva statue of Ōkuradera-temple,
Nara pref. H: 10.5 W: 6.8
Nara National Museum

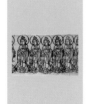

22. 阿弥陀如来来迎図（印仏）
1 紙　室町時代　15c.　元興寺極楽坊伝来
縦 25.5　長 37.7　奈良国立博物館所蔵
22. Stamps of Descent of Amida Nyorai (Amithāba)
One sheet placed in a scroll. Muromachi period. Previously
owned by Gokurakubō subtemple at the Gangōji-temple,
Nara pref. H: 25.5 W: 37.7
Nara National Museum

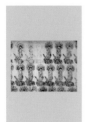

23. 吉祥天像（印仏）
1 紙　鎌倉時代　13c.　京都・浄瑠璃寺吉祥天立像
納入品　縦 7.5　横 43.3　奈良国立博物館所蔵
23. Stamps of Sri-mahadevi
One sheet. Kamakura period. Originally enclosed inside the
Sri-mahadevi statue of Jōruriji-temple, Kyoto pref.
H: 7.5 W: 43.3
Nara National Museum

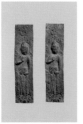

24. 観音菩薩像（押出仏）
2 面　奈良時代　8c.　銅造 板金 打出
その1：22.9 × 5.4 × 0.3 、その2：22.9 × 5.3 × 0.3
奈良国立博物館所蔵
24. Standing Kannon (Avalokiteśvara) in Relief
Two pieces. Nara period. Bronze in relief.
[No.1] H: 22.9 W: 5.4 D: 0.3, [No.2] H: 22.9 W: 5.3 D: 0.3
Nara National Museum

25. 十一面観音像（東大寺二月堂本尊）光背断片
1片　奈良時代　8c.　奈良・東大寺伝来　銅製　鍍金
縦 7.6　横 4.5　厚 0.4　奈良国立博物館所蔵

25. Fragment of the mandorla for the Jūichimen Kannon
(Eleven-headed Avalokiteśvara, the chief worship of the
Nigatsudō Hall at Tōdaiji temple)
One fragment. Nara period. Previously owned by Tōdaiji-
temple, Nara pref. Gilt bronze. H: 7.6 W: 4.5 D: 0.4
Nara National Museum

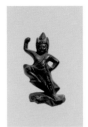

26. 懸仏残欠（蔵王権現像）
1個　鎌倉時代　13c.　銅製　鋳造　像高 13.9
鏡板欠失　奈良国立博物館所蔵

26. Standing Zaōgongen (part of a votive plaque)
One piece. Kamakura period. Bronze, casted. H: 13.9
Missing the mirror of its background.
Nara National Museum

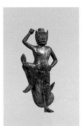

27. 重要文化財　蔵王権現立像
1軀　平安時代　12c.
銅造　鋳造　鍍金　像高 30.5　奈良国立博物館所蔵

27. I. Standing Zaōgongen
One statue. Heian period. Gilt bronze, casted. H: 30.5
Nara National Museum

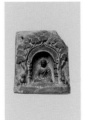

28. 方形独尊坐像塼仏（中国出土品）
1面　六朝（南北朝）〜隋時代　6〜7c.
塼製　土製　型押　焼成　素焼　縦 18.2　横 15.8
奈良国立博物館所蔵

28. Seated Buddha in a Niche (excavated in China)
One object. Six dynasties period (Northern and Southern
dynasties) to Sui dynasty period. Clay and earth soil placed
in a mold and fired. H: 18.2 W: 15.8
Nara National Museum

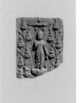

29. 塼仏（如来像）
1枚　唐時代　8〜9c.　塼製　型押
縦 7.9　横 6.0　厚 1.3　奈良国立博物館所蔵

29. Tile of Nyorai Buddha
One object. Tang period. Clay placed in a mold.
H: 7.9 W: 6.0 D: 1.3
Nara National Museum

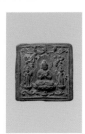

30. 方形阿弥陀三尊塼仏（中国出土品）
1面　唐時代　7c.　塼製　土製　型押
焼成　素焼　縦 8.8　横 8.8　奈良国立博物館所蔵

30. Tile of Standing Amidabha Triad, Excavated in China
One object. Tang period. Clay and earth soil placed in a
mold and fired. H: 8.8 W: 8.8
Nara National Museum

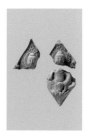

31. 重要美術品　六角塼仏（如来像）断片
三重県天華寺跡出土　2面のうち　白鳳時代　7c.　塼製
土製　型押　焼成　縦 22.0　横 14.0　厚 4.5（復元時）
奈良国立博物館所蔵

31. Important Art object. Part of Nyorai Buddha in Hexagonal
Tile (Excavated from the Tengeji-temple site, Mie pref.)
One of two objects. Hakuhō period. Clay placed in a mold
and fireed. H: 22.0, W: 14.0 D: 4.5 (restored size).
Nara National Museum

32. 塼仏（三尊像）断片　三重県夏見廃寺出土
5片のうち　白鳳時代　7c.　塼製　土製　型押　焼成
奈良国立博物館所蔵

32. Part of Fragments of Buddha Triad (Excavated from
the Abandoned Natsumi haiji-temple site, Mie pref.)
One of five pieces. Hakuhō period.
Clay placed in a mold and fired.
Nara National Museum

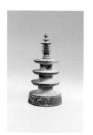

33. 百万塔
1基　奈良時代　8c.　木製　高 21.5　奈良・法隆寺伝来
相輪底裏墨書「真」　塔底裏墨書「云二四廿左和万」
陀羅尼残欠附属　奈良国立博物館所蔵

33. One Million Pagoda
One object. Nara period. Wood. H: 21.5 Originally housed in
Hōryuji-temple, Nara pref. Inscriptions: " 真 " on the bottom of
the finial, " 云二四廿左和万 " on the bottom of the pagoda. Remains
of Dharani sutra preserved separately. Nara National Museum

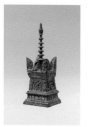

34. 銭弘俶八万四千塔
1基　五代時代　10c.　銅製　鋳造　高 22.0
内壁面線刻「呉越國王／銭弘俶敬造／八万四千寳／
塔乙卯歳記」「安」　奈良国立博物館所蔵

34. Eighty-four Thousand Stupas Offered by Qian Hongchu
One item. Five Dynasties. Bronze, casted. H: 22.0
Inscription inside: " 呉越國王／銭弘俶敬造／八万四千寳／
塔乙卯歳記 " " 安 "
Nara National Museum

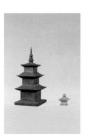

35. 舎利容器（層塔形）・内容器
2 基　高麗時代　10 ～ 14c. 層塔形：銀板製　鑞付
総高 13.7、内容器：金製　鑞付　総高 2.66
奈良国立博物館所蔵

35. Pagoda-shaped Reliquary and Inside Container
Two items. Goryeo period. Pagoda: Silver plate, brazed.
H: 13.7 Container: Gold, brazed. H: 2.66
Nara National Museum

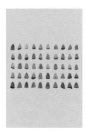

36. 塑像螺髪　鳥取県斉尾廃寺出土品
50 個のうち　白鳳時代　7c. 土製
高 2.6 ～ 3.8　底径 1.8 ～ 2.0
奈良国立博物館

36. Crinkled Hair of Buddha Statue
One of fifty items. Hakuhō period. Clay. H: 2.6-3.8
Diameter: 1.8-2.0 Excavated from the abandoned Saino'o
haiji-temple site, Tottori pref.
Nara National Museum

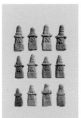

37. 一字一塔泥塔経　鳥取県智積寺経塚出土
12 個のうち　鎌倉時代　13 ～ 14c. 土製　型抜　箆書 線刻
焼成　素焼　高約 5.2 ～ 6.7　塔身に地蔵菩薩の種子「カ」陽出
基部や裏面に法華経の経文を刻む　奈良国立博物館所蔵

37. Clay Pagodas Inscribed With Every Characters of Lotus Sutra,
Excavated from a sutra mound in Chishakuji-temple, Tottori pref. One of
Twelve items. Kamakura period. Clay placed in a mold, Chinese character
from the sutra inscribed, a Sanskrit character of Kṣitigarbha casted in the
middle. H: 5.2 - 6.7 Nara National Museum

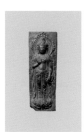

38. 観音菩薩像
1 面　奈良時代　8c. 銅板製　鋳造
縦 22.3　横 7.8
奈良国立博物館所蔵

38. Standing Kannon (Avalokiteśvara)
One piece. Nara period. Bronze relief, casted.
H: 22.3 W: 7.8
Nara National Museum

39. 重要文化財　鏡像（阿弥陀如来像）
1 面　平安時代　12c. 白銅製　鋳造　径 20.5
奈良国立博物館所蔵

39. I. Amida Nyorai (Amithāba) Inscribed on a Mirror
One piece. Heian period. White bronze, casted.
Diameter: 20.5
Nara National Museum

40. 鏡像（如来三尊）
1 面　平安時代　11～12c.　金峯山経塚（奈良県吉
野郡吉野町）出土　銅製　鋳造　径 10.8
奈良国立博物館所蔵
40. Amida (Amithāba) Triad Inscribed on a Mirror
One piece. Heian period.
Excavated from Kinpusen-kyōzuka sutra mound in Nara pref.
Bronze, casted. Diameter: 10.8
Nara National Museum

41. 塑像白毫（鳥取県斉尾廃寺出土品）
1 個　白鳳時代　7c.　土製　高 2.8　底径 3.5
奈良国立博物館所蔵
41. Urna of Buddha Statue
One item. Hakuhō period. Clay. Excavated from the
abandoned Saino'o haiji-temple site, Tottori pref. H: 2.8
Diameter: 3.5
Nara National Museum

42. 仏名経印仏
2 紙　鎌倉時代 13c.　(1) 紙本　墨印　巻子貼交
(2) 紙本　墨印　淡彩　巻子貼交 (1) 縦 27.1　横 10.8
(2) 縦 27.1　横 19.4　奈良国立博物館所蔵
42. Buddha Stamps with Butsumyōkyō Sutra
Two sheets. Kamakura period. [No.1]: Ink stamps on paper,
glued on a scroll. H: 27.1 W: 10.8 [No.2]: Ink stamps with
color on paper, glued on a scroll. H: 27.1 W: 19.4
Nara National Museum

43. 瓦経（法華経）鳥取県大日寺経塚出土
1 枚　平安時代　11c.　土製　箆書　縦 22.0　横 9.4
厚 1.2　裏面箆書「結縁僧教尊／大勧進沙門僧成縁」
側面箆書「妙法」　法華経従地涌出品第十五
奈良国立博物館所蔵
43. Clay Sutra (Lotus Sutra), Excavated from a sutra
mound in Dainichiji-temple, Tottori pref.
One item. Heian period. Clay H: 22.0 W: 9.4 D: 1.2
Nara National Museum

作品の法量（寸法）の単位はセンチメートルである。
Measurements are given in centimeters.

出典等付記（掲載順）　　Bibliography (in order of quotation)

「山中に何の楽しびか有る」『性霊集』巻第 1　空海（774-835）
Shōryōshū, First volume, by Kūkai（774-835）
(from the "Couplets of various length on the theme of 'What is Pleasant in the Mountains'")
「高野山中に何の楽しみがあって、こんなに長く留まり帰ることを忘れているのだろう。」と
始まる一節。自然のなかで生かされる喜びが綴られる。

『法句経』法救　撰　維祇難等　訳
Dhammapala
仏陀の真理の言葉ともいわれる。

『諷誦啓矇集』観空
Fujukeimōshū, edited by Kankū, published in 1719
諷誦文（供養法要等て読経のあとに僧侶が読む文）などを編纂した享保 4 年(1719)刊の書の一節。

『般若波羅蜜多心経』玄奘（602-664）訳
Heart Sutra
現代の日本でもっとも広く読経されている「般若心経」の一節。

『金剛般若波羅蜜経』鳩摩羅什（344-413）訳
Diamond Sutra
釈迦と須菩提との対話で構成される経典の一節。煩悩を智慧によって破ることを説く。

「天長皇帝大極殿にして百僧を屈する雩の願文」
『性霊集』巻第 6　空海
Shōryōshū, Sixth volume, by Kūkai
(from the "Dedicatory prayer for the Tenchō Emperor sponsored prayer for rain at the Daigokuden")
淳和天皇による宮中大極殿での雨乞いの祈祷の際に読まれた願文。百僧を招集して行われた。

「招提寺の達嚫文」『性霊集』巻第 8　空海
Shōryōshū, Eighth volume, by Kūkai
(from the "Dedicatory prayer for the rite at Tōshōdaiji temple")
承和元年（834）2 月、奈良・唐招提寺の供養奉納のための文。
唐招提寺は奈良時代、戒律を伝えるため度重なる苦難を経て中国から来日した鑑真の創建。

「四恩の奉為に二部の大曼荼羅を造る願文」『性霊集』巻第 7　空海
Shōryōshū, Seventh volume, by Kūkai
(from the "Dedicatory prayer on the creation of the Two Great Mandalas")
四恩（父母、民、国王、三宝）のために金剛界曼荼羅と胎蔵曼荼羅をつくる願文。
悟りにいたる道がわからずにいくたびか泣いたことがあることを記す。

『山家心中集』西行（1118-1190）
Verse by Saigyō (1118-1190) from *Sankashinjūshū*
平安時代末から鎌倉時代はじめの僧・歌人。
「もろともに…」は、慕った西住上人が病に倒れ、月明りをみて詠んだ一首。

『金葉和歌集』覚樹（1081-1139）
Verse by Kakuju (1081-1139) from *Kin'yōwakashū*

平安時代後期の東大寺三論宗の僧・歌人。源顕房の子。
「普賢十願文に願はくば我命終せんと欲する時に臨みてといへる事をよめる」として詠まれた一首。

『方丈記』鴨長明（1155-1216）
Hōjōki or *An Account of My Hut* by Kamo no Chōmei (1155-1216)

平安時代末から鎌倉時代前期の歌人・随筆家で、賀茂御祖神社の禰宜の家に生まれた。
建暦2年（1212）に山中の庵で記されたとされる。

『国家珍宝帳』（外題「東大寺献物帳」）
Kokka chinpōchō (*Ledger of the Nation's Rare Treasures*) dated 21st day of the sixth month of 756.

奈良時代、天平勝宝八歳（756）6月21日の聖武天皇の七七忌にあたり、遺愛品をはじめとする
宝物を東大寺毘盧遮那仏に奉献した際の目録。冒頭と巻末に光明皇后御製の願文があり、引用は
巻末の一節。
「右の件、皆是れ、先帝翫弄の珎にして、内司供擬の物なり。疇昔を追感し、目に觸るれば崩摧
す。謹みて以て盧舎那仏に献じ奉る。／伏して願わくは、此の善因を用て冥助に資し奉り、早く
十塵に遊び、普く三途を済り、然る後に攀を花蔵の宮に鳴らし、躃を涅槃の岸に住めんことを。
／天平勝寳八歳六月廿一日」

「酒人の内公主のための遺言」『性霊集』巻第4　空海
Shōryōshū, Fourth volume, by Kūkai
(from the "Testament of Princess Sakaudo")

弘仁14年（823）の遺言の代作。子に先立たれた老齢の内親王（光仁天皇皇女）が、兄弟らに
自身の死後を託す内容。土葬にて土に還ること、副葬品も簡素なものとすることを記す。

「亡弟子智泉が為の達嚫の文」『性霊集』巻第8　空海
Shōryōshū, Eighth volume, by Kūkai
(from the "Dedicatory prayer for the late-disciple Chisen")

亡くなった弟子智泉のため、供物をささげる文として師の空海が草した。
多くの教えを伝えた有能な弟子の逝去に、つよい悲嘆を隠さず記す。

「藤原園人遺族宛書翰」『高野雑筆集』空海
Kōyazappitsushū, by Kūkai
(from the "Letter to the bereaved family of Fujiwara no Sonohito" dated the twelfth month of 818)

弘仁9年（818）12月、高野山で右大臣藤原園人の訃報に接し、遺児の藤原浜主へ宛てた手紙。
年の瀬に近づく頃、服喪する遺族へ心身を労わるよう気遣う文面の一節。

「藤左近の将監、先妣の為に三七の斎を設くる願文」『性霊集』巻第8　空海
Shōryōshū, Eighth volume, by Kūkai
(from the "Dedicatory prayer for 21st-day memorial service sponsored by Fujiwara Sakon no Shōgen for his
deceased mother")

左近衛府の判官だった藤原氏（不詳）の亡母の三七日忌法要を行う際の願文。
「逝者は怡楽し、留まる人は苦しぶ。痛ましい哉。苦しい哉。」と遺族の心を慮る一節もある。

凡例
・本書には人の生老病死について先人が記した経文、願文、和歌などから原文を一部引用し収録した。
・収録文は、写真の作品に関連して補足説明するものではなく、文字による作品として収めた。
・原文とともに現代語訳をつけて解釈の一助としたものもある。
・通常、縦書きの書籍は右開きが慣例であるが、英文併記のため左開きとした。
・「世紀」は c. と略した。

Notes
 - This book contains selected passages from Buddhist scripture as well as Japanese prayers and poetry written by past generations concerning human afflictions and suffering.
 - These passages are not intended to explicate the photos of the Buddhist icons that they accompany.
 - The Chinese-language originals are accompanied by modern-Japanese and English translations.
 - The original texts that are normally written vertically from right to left have been altered to conform to the English translations and read from left to right.

Translator's notes
 - The English translations are primarily based on the Chinese and Sinitic versions of the texts, but the Japanese translations have been consulted and they are sometimes reflected in the English.
 - Elements in brackets have been added to assist the English reader in grasping the sense of the original.

Abbreviations
c.: century
I: Important Cultural Property.
H/W/D: Height/Width/Depth of the object.

画像提供　Photo Credits
Image: TNM Image Archives
　掲載番号 3、7-9、14、17-18
奈良国立博物館　佐々木杏輔 Kyosuke Sasaki, Nara National Museum
　表紙、掲載番号 13、25、27、28、30-32、34、36、41、43
奈良国立博物館　森村欣司 Kinji Morimura, Nara National Museum
　上記以外の写真すべて The rest of the photos,

参考文献
『大正新脩大蔵経』大正新脩大蔵経刊行会
『浄土分類諷誦啓瞭集』3 巻　観空 著（1719）
『正倉院の書蹟』正倉院事務所編　日本経済新聞社　（1964）
『復刻日本古典文学館 13　山家心中集　宮本家本』西行 著　日本古典文学学会編（1971）
『校刊美術史料 寺院篇 中巻』藤田経世 編 中央公論美術出版（1972）
『諷誦・歎徳・表白・引導大宝典』釈慶巌 編　国書刊行会（1984）
『西行法師全歌集　纂訂』伊藤嘉夫 編著 第一書房（1987）
『新日本古典文学大系 9　金葉和歌集 詞花和歌集』川村晃生ほか 校注　岩波書店（1989）
『新日本古典文学大系 46　中世和歌集 鎌倉篇』樋口芳麻呂ほか 校注 岩波書店（1991）
『定本弘法大師全集』第 7 巻　空海 著　密教文化研究所弘法大師著作研究会編（1992）
『新国訳大蔵経 2 本縁部 4』引田弘道 校注 大蔵出版（2000）
『傍訳 弘法大師空海　性霊集』3 巻　宮坂宥勝 編著　四季社（2001）
『ワイド版東洋文庫 469 八代集』第 3 巻　奥村恒哉 校注　平凡社（2008）
『新潮日本古典集成　方丈記　発心集』鴨長明 著　三木紀人 校注　新潮社（2016）

謝辞
本書の制作にあたり多くの方のご協力を賜りました。心より厚く御礼申し上げます。

てのひらのみほとけ

2018 年 12 月 13 日 初版第 1 刷発行

序文 高橋睦郎
翻訳 マイケル・ジャメンツ
協力 ルーク・トンプソン
アートディレクション 高岡一弥
デザイン 後藤寿方, 神崎美穂
校正 株式会社 鷗来堂
編集 原瑛莉子

印刷・製本 株式会社 東京印書館

発行人 三芳寛要
発行元 株式会社 パイ インターナショナル
〒 170-0005 東京都豊島区南大塚 2-32-4
TEL 03-3944-3981　FAX 03-5395-4830
sales@pie.co.jp